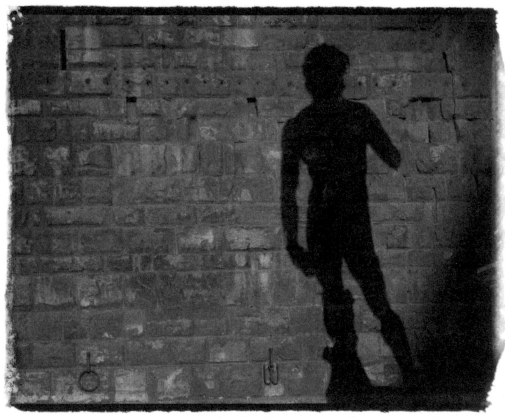

David's shadow, Florence

ITALIAN DREAMS

Photographs by Steven Rothfeld

Introduction by Franco Zeffirelli

CollinsPublishersSanFrancisco
A Division of HarperCollinsPublishers

For my personal trinity
Susan
Marika
Milan

Heartfelt thanks to Kari Perin for her inexhaustible energy, patience, support and impeccable design sense; Jennifer Barry and Maura Carey Damacion for giving me the opportunity to express my passion for Italy and their assistance in its refinement; Peter Workman, for encouraging and giving a name to my dreams; Mimi Murphy, for her myriad talents as friend, translator, diplomat, writer, and safe harbor in Rome; *European Travel & Life, Bon Appétit,* *Food & Wine* magazines; the Los Angeles offices of the Italian Cultural Institute and Italian Government Tourist Board; Joshua Poole of Ciga Hotels; Elke and Dave Williamson for providing inspirational spaces to work in, and the friends who have shared the pleasures of Italy: David Breul, Jeanne Dzienciol, Judy Fayard, Karen Kaplan, Dan Miller, Joel Rothfeld, Patricia and Walter Wells, and my parents . . . always.

First published in USA 1995 by Collins Publishers San Francisco
Copyright © 1995 Collins Publishers San Francisco
Photographs copyright © 1995 Steven Rothfeld
Creative Director: Jennifer Barry
Design: Kari Perin
Production Assistant: Kristen Wurz
Calligraphy: Jane Dill
Library of Congress Cataloging-in-Publication Data
Rothfeld, Steven.
Italian Dreams / photographs by Steven Rothfeld.
p. cm.
ISBN 0-00-225066-7
1. Italy--Pictorial works. I. Title.
DG420.R67 1995
945--dc20 CIP 95-9105
Printed in Italy 10 9 8 7 6 5 4 3 2 1

INTRODUCTION

When Steven Rothfeld asked me to write a few words of introduction for his new book of dreams—Italian Dreams—my first instinct was to get out of it with a curt "no". For what is more difficult than commenting on images? And aren't images what they are precisely because they are not objectively commentable? How can words expand on the eloquence of images? An illustration is different; it illustrates—for better or worse—some thing. It refers to it, accompanies it, explains it. It doesn't evoke emotions by itself; it doesn't make one dream. But an image is a whole other thing. An example: here in this volume is an image of a window that opens (or closes?) on a Tuscan countryside. Cypress trees follow each other in a row, softly winding through a landscape that is known to you: perhaps you have been there, or else you have seen it in the background of a painting, perhaps by Leonardo da Vinci, or maybe you dreamed it, summing up so many visions of Tuscany.

It's certain that here, glimpsing it, you recognize it, and you are nostalgic if you have been there, or you long to go there if you have never been. It is, in effect, an image that shows you the essence of that particular landscape. And you can even hear the chirping of the crickets that will cease all of a sudden if that window closes, that will become a deafening summer concert if the window opens wide and lets the sun enter.

I was born in Florence many years ago. To be born in Italy and in Florence is good fortune: you have only to raise your eyes and Art and Beauty come to meet you. And you are fortunate not only for the wealth of works of art and cultural messages that rise unexpectedly from everywhere and that are not only a part of, but actually constitute the very fabric from which this country is made. You are also fortunate for the traditions, for the many civilizations that have woven together, have mixed, have looked around them and have decided to stay here forever. For this, Italy is the most beautiful country in the world.

In what other country could it happen that a band of breathless kids, thirteen or fourteen years old, (I among them), plays wildly at soccer in the courtyard of a cloister, under the astonished glance of angels and Madonnas that flowed from the brush of Fra Angelico? In what other city of the world is it given that a boy, to get to school, finds himself every day crossing streets and squares laden with History, Architecture, archetypes of the Ideal City?

I also had the good fortune as a child to live long periods in the country; to savor completely natural odors, flavors, moods, to be in contact with the earth and with the animals, to run barefoot, to toil in the field, to scythe the grass and milk the cow, to share with humble people ancient, still unchanged gestures, to listen to accents not yet bastardized by the simulated and stereotyped language of the television commentator. And this too, along with the noble archetypes of my city, taught me to dream.

Leonardo said that one never recovers from one's own childhood.
And I am very happy that this malady has never abandoned me.
On the contrary, my childhood, my malady, is so well rooted in me
that it nourishes me still. It was with the germs of this particularly
Tuscan ailment that I constructed step by step all of my work and,
therefore, my life. And, while nourishing oneself with so much
beauty, so much civility, is certainly fortunate, it also causes the true
Florentine to be his own worst enemy: hypercritical, hyperanalytic.
Exacting as he is, he carries with him the taste for work well done,
which can become his fortune but also his damnation, because
nothing ever seems really complete.

I look with my Italian eyes upon the work of Steven Rothfeld,
and very probably I read in his images—yes, his are really images—
ideas and suggestions that perhaps his foreign eyes never thought to
arouse, and I amuse myself guessing why he might have chosen that
particular detail, that roof, that sky, that church. I see, finally, the
image made in The Frari church in Venice. And it reminds me of
myself, as a child, playing under the sublime frescoes of Fra Angelico
in the cloister of San Marco in Florence. I look at the two children
who are running in this photograph and I seem to recognize myself.
Perhaps this is why—in the end—I surrendered, and I accepted,
writing these words of good wishes for this beautiful book.

—Franco Zeffirelli, Rome, 1995

The illusion Italy creates is a relief . . .
The Italian way of life down the centuries
attracted people who wanted to take a
holiday from their national virtues. In
the heart of every man, wherever he is
born, whatever his education and tastes,
there is one small corner which is Italian,
that part which finds regimentation
irksome, the dangers of war frightening,
strict morality stifling, that part which
loves frivolous and entertaining art,
admires larger-than-life-size solitary
heroes, and dreams of an impossible
liberation from the strictures of a tidy
existence. ~Luigi Barzini

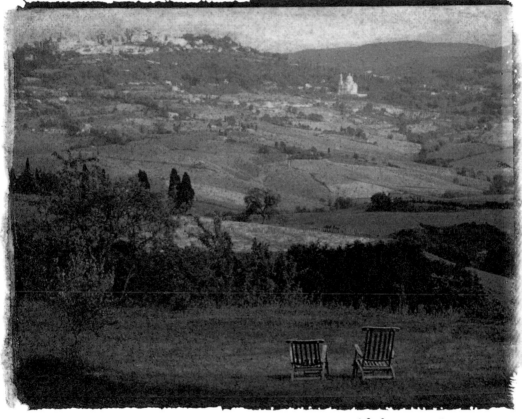

Hilltops, Tuscany

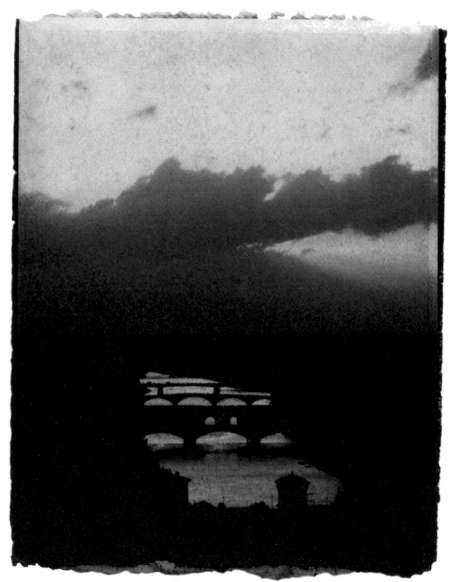

Bridges, Florence

My soul, affected by the very notion
of being in Florence … was already
in a state of trance. ~Stendhal

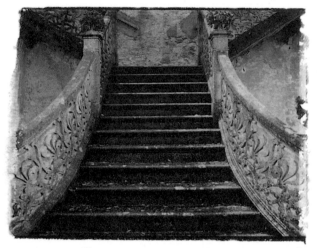

Staircase, Izzalini-Casproli

These things remain for the most
part in sound preservation, and,
as the weeks go by and you spend a
constant portion of your days
among them the sense of one of
the happiest periods of human
Taste ~ to put it only at that ~
settles upon your spirit.
~Henry James

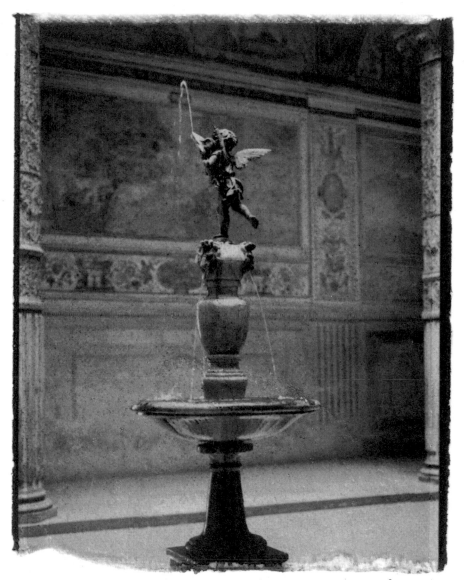

Palazzo Vecchio courtyard, Florence

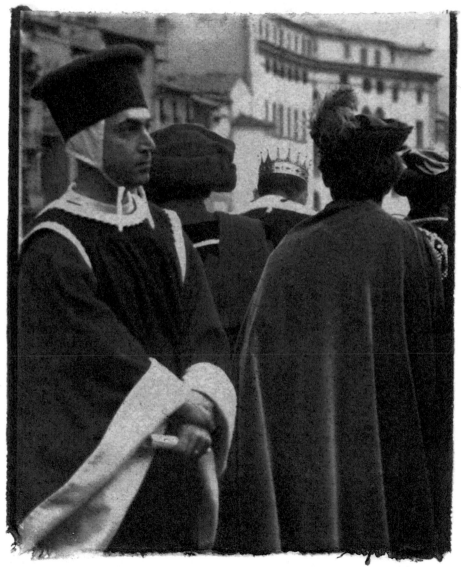

Pageant, Florence

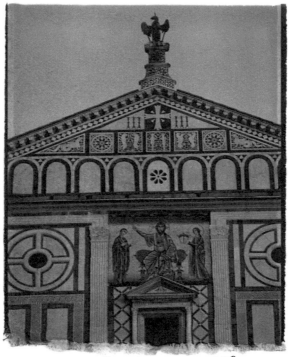

San Miniato, Florence

In contrast to so much confusion
of thought, what order, what clarity,
what distinction, what subtlety of
composition, what delicacy of
moulding in the facade of San
Miniato! ~ Bernard Berenson

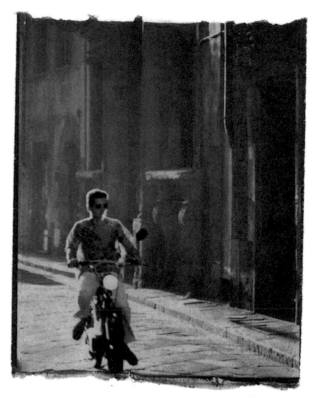

Via Santo Spirito, Florence

Oh, what I would give for an
Italian sense of style.
~Barbara Grizzuti Harrison

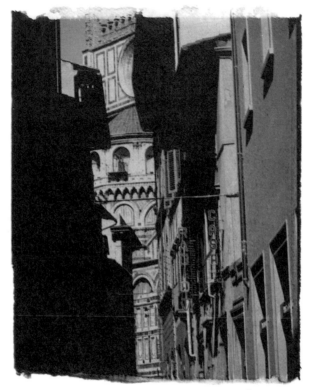

Duomo, Florence

Italy is so tender
~ like cooked
macaroni~ yards
and yards of
soft tenderness,
ravelled round
everything.
~ D.H. Lawrence

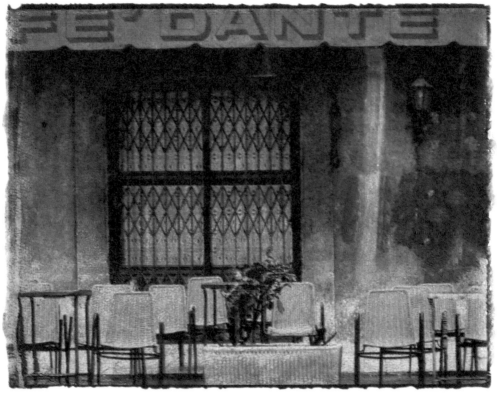

Caffè, Verona

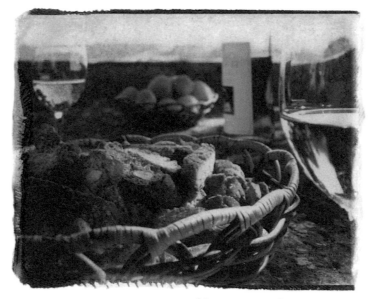

Biscotti, Amoroso

There is no such thing as Italian
'haute cuisine' because there are no
high or low roads in Italian cooking.

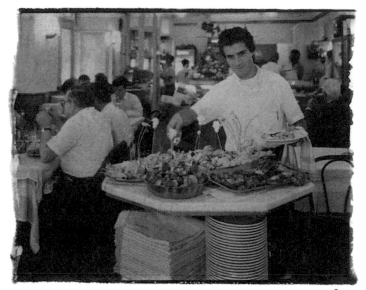

Antipasti, Naples

All roads lead to the home, to 'la cucina di casa'—the only one that deserves to be called Italian cooking.
~Marcella Hazan

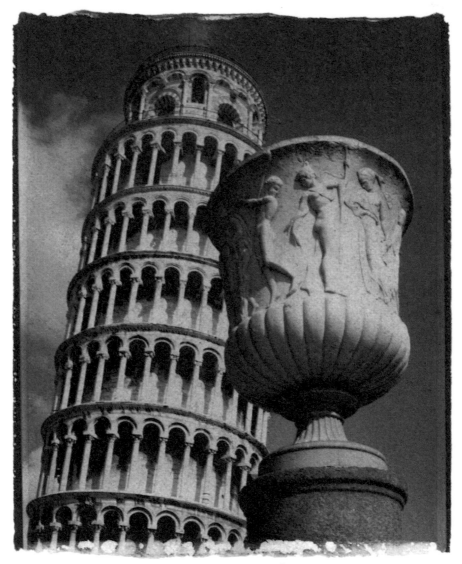

Leaning Tower, Pisa

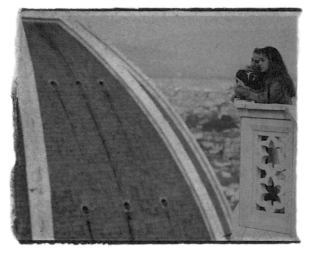

Cupola, Florence

For architecture, among all the
arts, is the one that most boldly
tries to reproduce in its rhythm
the order of the universe, which
the ancients called "kosmos," . . .
—Umberto Eco

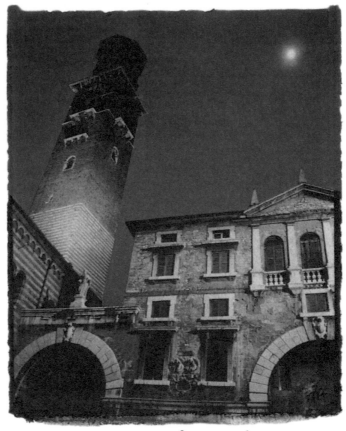

Torre dei Lamberti, Verona

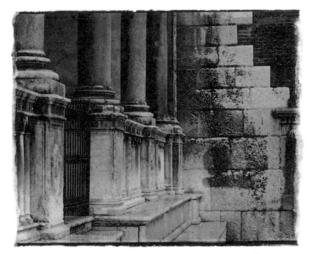

Corner, Verona

There is no world without Verona
walls. But purgatory, torture, hell
itself. ~William Shakespeare

Piazza San Marco, Venice

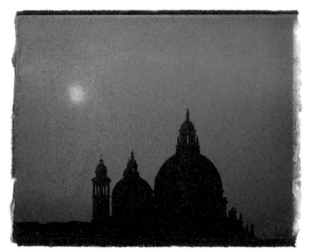

Silhouette, Venice

Over all broods that mysterious
stillness, that stealthy quiet, that
befits so well this old dreaming
Venice. —Mark Twain

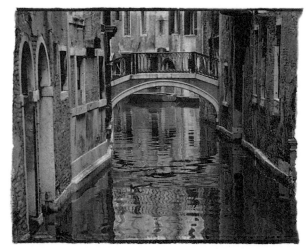

Bridge, Venice

Every door that half opens seems
to give egress to a lover or a
bravo, every gondola which glides
by silently must surely bear away
a couple of lovers or a dead body
with a broken stiletto planted in
its heart. ~Theophile Gautier

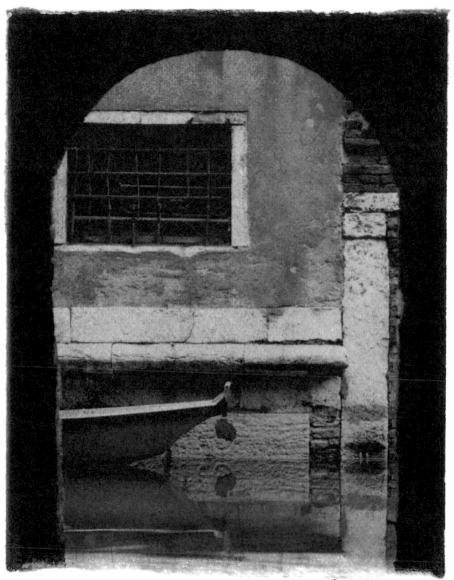

Archway, Venice

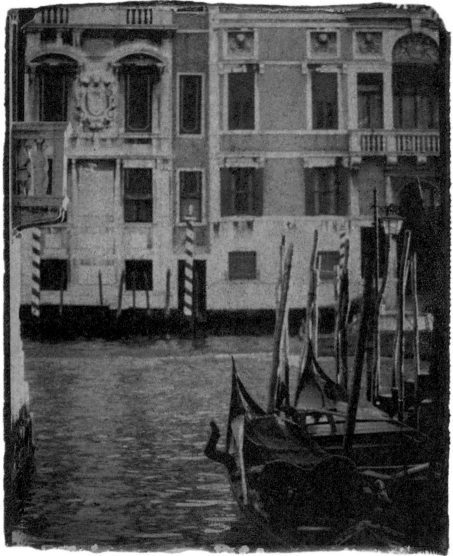

Grand Canal, Venice

Dear old Venice has lost her
complexion, her figure, her
reputation, her self-respect; and
yet, with it all, has so puzzlingly
not lost a shred of her distinction.
~Henry James

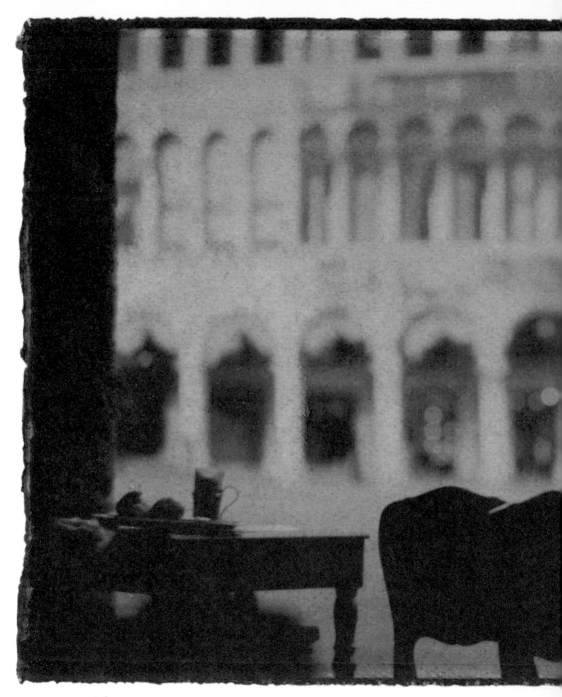

Caffè Florian, Venice

The tourist Venice _is_ Venice: the
gondolas, the sunsets, the changing
light. Florians, Quadri's, Torcello,
Harry's Bar, Murano, Burano,
the pigeons, the glass beads, the
vaporetto. Venice is a folding
picture-post-card of itself.
~Mary McCarthy

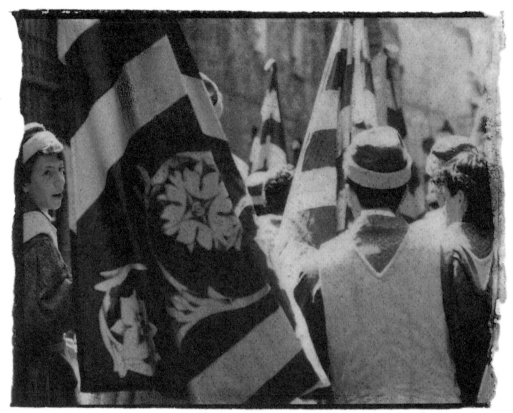

Palio, Siena

To be in Siena only on a Palio day is to see it in orgasm

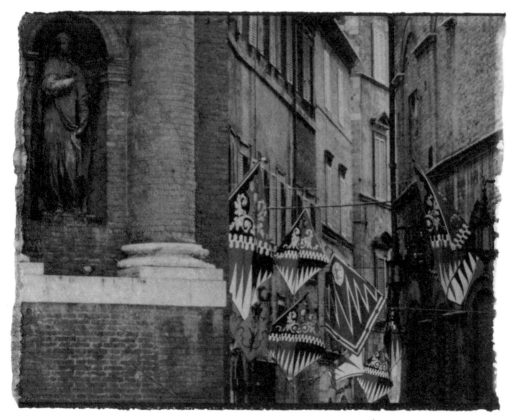

Banners, Siena

and consequently at least a bit deceptive. ~Kate Simon

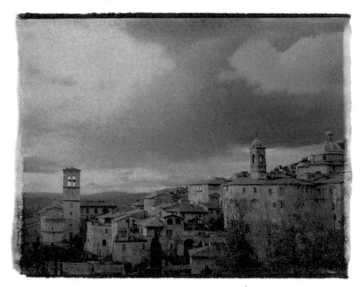

Winter, Assisi

What miracle was this? Where
was I? Houses, citadel, churches,
towers: all were hovering in the
air... Is this Assisi? I kept asking
myself, making the sign of the
cross... or is it possible that, while
still alive, I have entered Paradise?
~ Nikos Kazantzakis

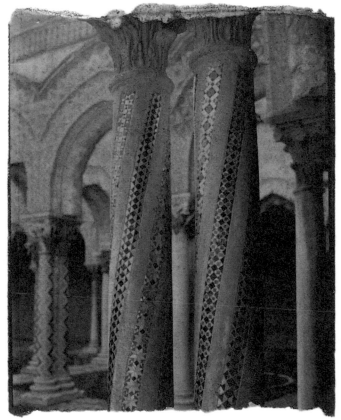

Cloister, Monreale

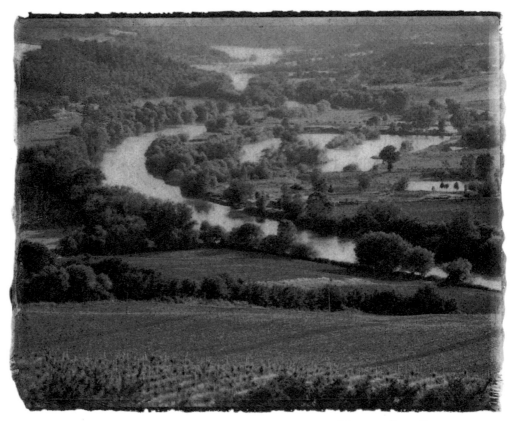

River bend, Orvieto

Spa, Montecatini Terme

Springs, too he created, and great
pools and lakes, and confined
between sloping banks the rivers
which flow down from the hills…
~ Ovid

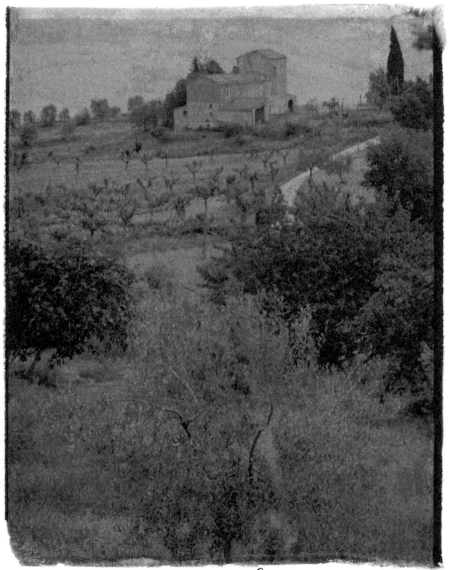

Farmhouse, Montefollonico

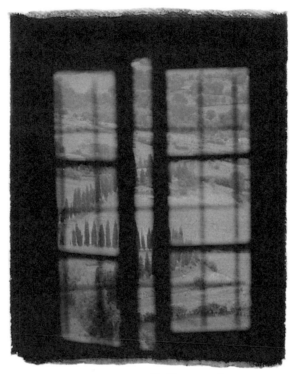

View, Tuscany

Dreaming through the noble
Tuscan landscape...I feel that
life is altogether bounteous and
good, lovable, manageable, sweet.
~Barbara Grizzuti Harrison

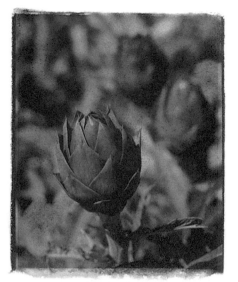

Carciofi, Menfi

Campo dei Fiori, Rome

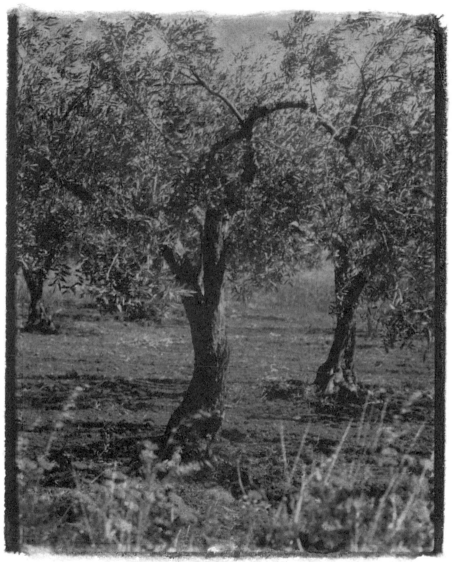

Olivi, Donnafugata

... the garden ... was exhaling scents that were cloying, fleshy, and slightly putrid, like the aromatic liquids distilled from relics of certain saints.

~ Giuseppe di Lampedus

Convent, Taormina

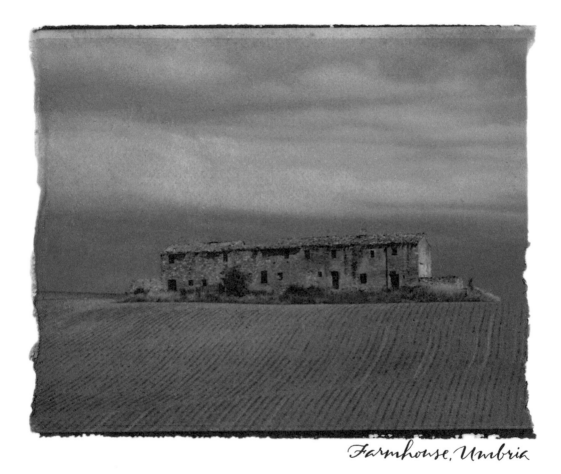

Farmhouse, Umbria

Part of the brooding expression
of these great houses comes, even
when they have not fallen into
decay, from their look of having
outlived their original use.
~Henry James

Espresso rapido, Perugia

*Love and understand the Italians,
for the people are more marvelous
than the land. ~ E. M. Forster*

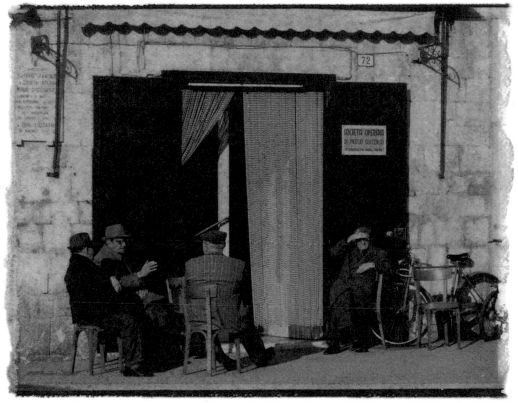

Pomeriggio, Molfetta

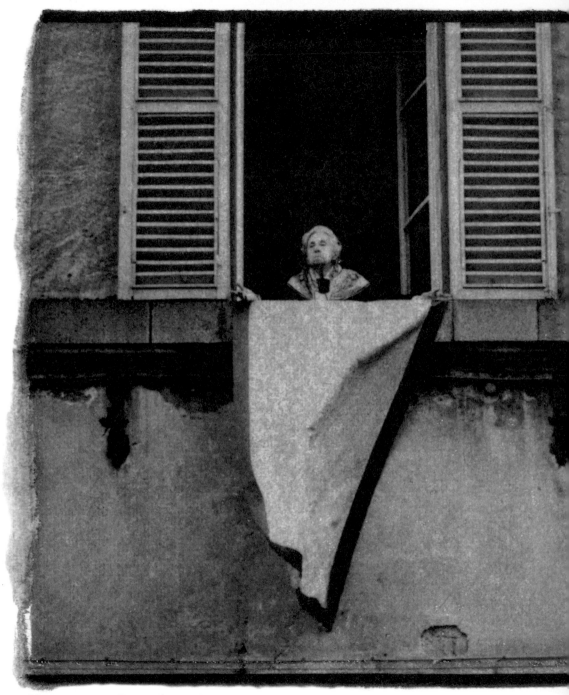

Pentecost Sunday, Orvieto

She seemed to be a country woman, with a simple, matronly face, which was solemnized and softened with the comfort that she had obtained by disburdening herself of the soil of worldly frailties and receiving absolution. ~Nathaniel Hawthorne

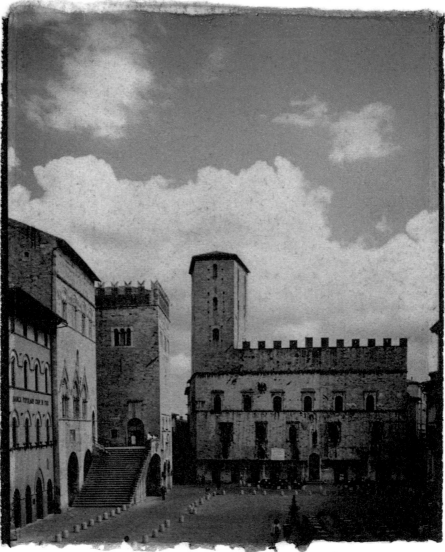

Piazza, Todi

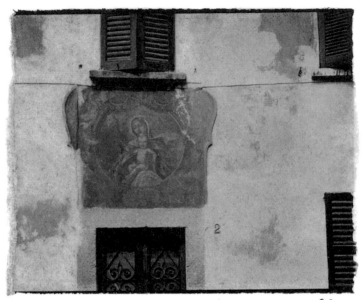

Madonna, Cernobbio

Every wall tells a story, every
house is a palace, every palace a
masterpiece and a legend.
~ Théophile Gautier

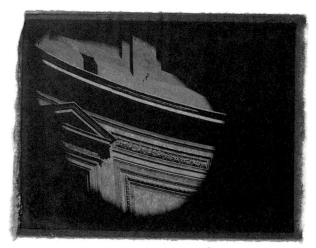

Pantheon, Rome

The more closely and precisely
one observes particulars, the sooner
one arrives at a perception of the
whole. ~ J.W. Goethe

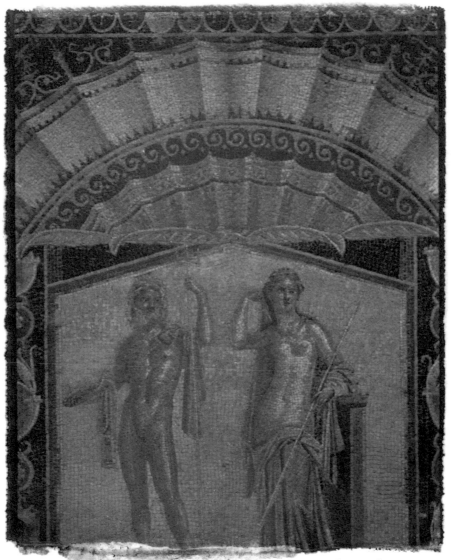

Mosaic, Herculaneum

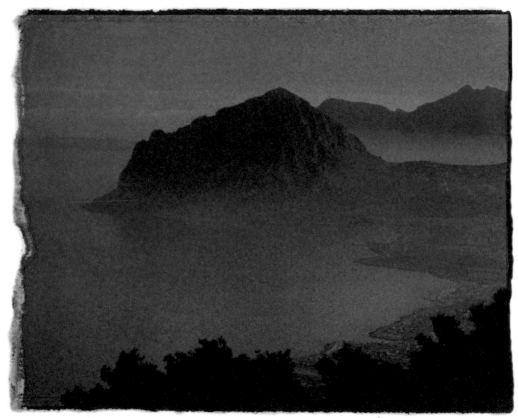

Panorama, Erice

With the color that paints the morning and evening clouds that face the sun I saw then the whole heaven suffused. ~ Dante

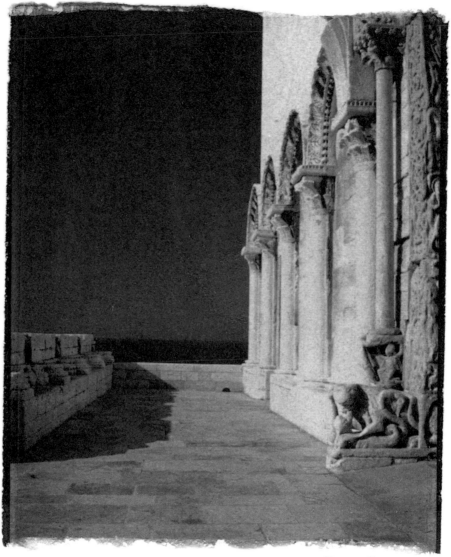

Portals, Trani

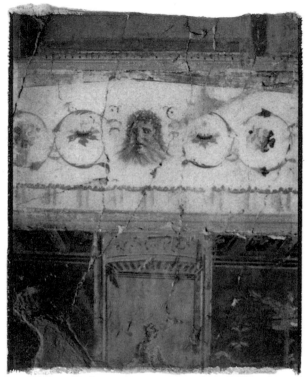

Wall painting, Herculaneum

The grass is never quite so green,
the sea is never quite so warm as
it used to be in the old days: The
past is magical because it is past.
~Bernard Wall

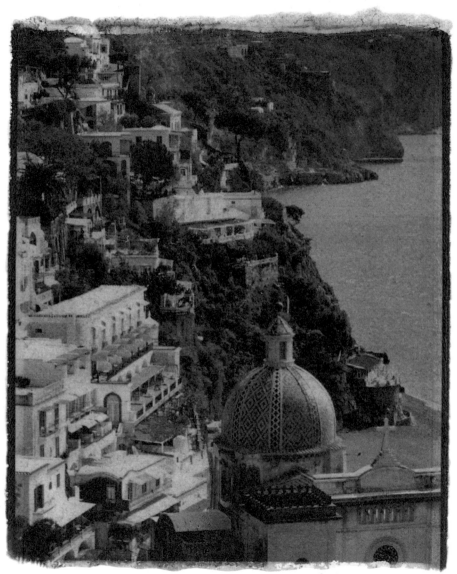

Vista, Positano

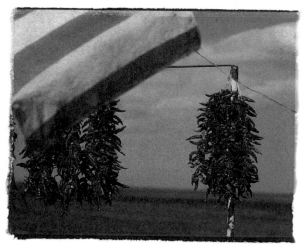

Peppers, Trebisacce

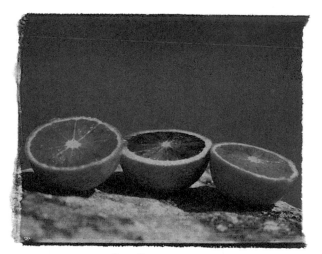

Blood oranges, Selinunte

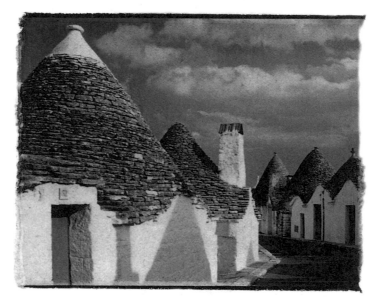

Trulli, Alberobello

We passed through the strangest,
funniest, undreamt of old towns,
wedded to the customs and
steeped in the dreams of the
elder ages, and perfectly unaware
that the world turns round!
~Mark Twain

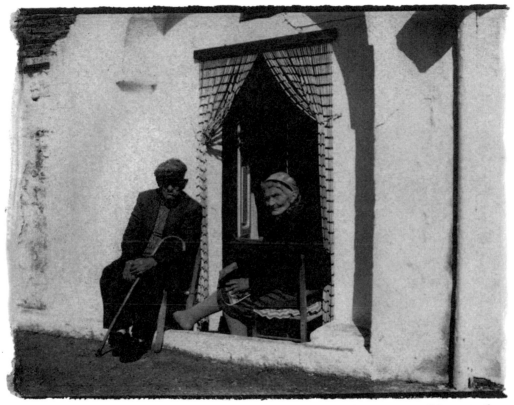

Repose, Alberobello

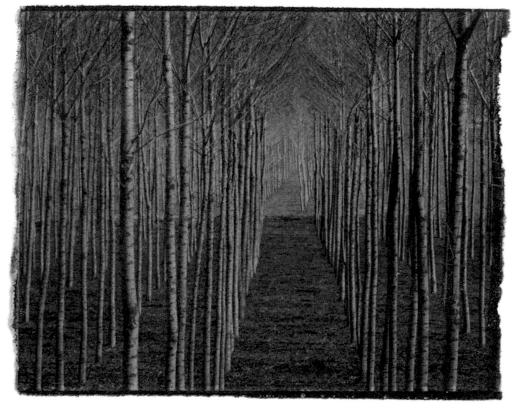

Grove, Piazza Armerina

I love all waste and
solitary places; where
we taste the pleasure
of believing what we
ee is boundless, as we
wish our souls to be.
~Percy Bysshe Shelley

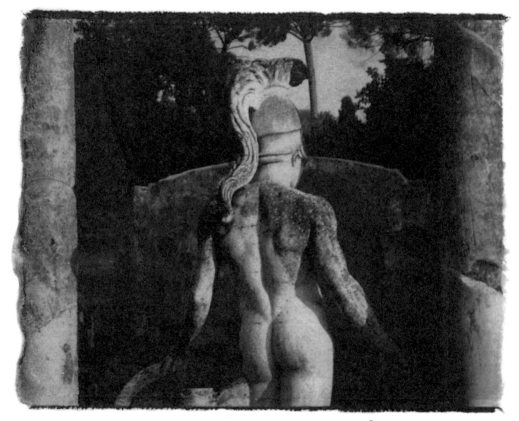

Gladiator, Tivoli

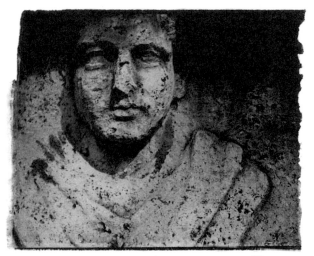

Gravestone, Rome

Who now looks at them, who
knows their names, who cares who
they were and what they achieved!
~ Bernard Berenson

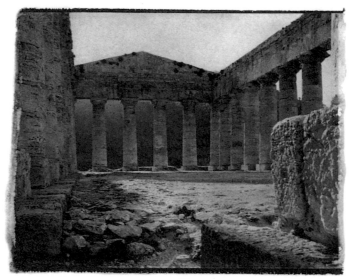

Sanctuary, Segesta

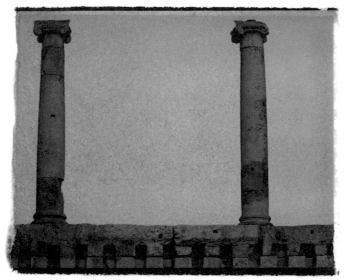

Remnant, Pompeii

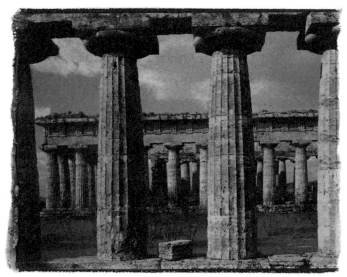

Columns, Paestum

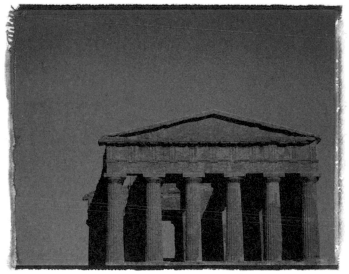

Temple, Agrigento

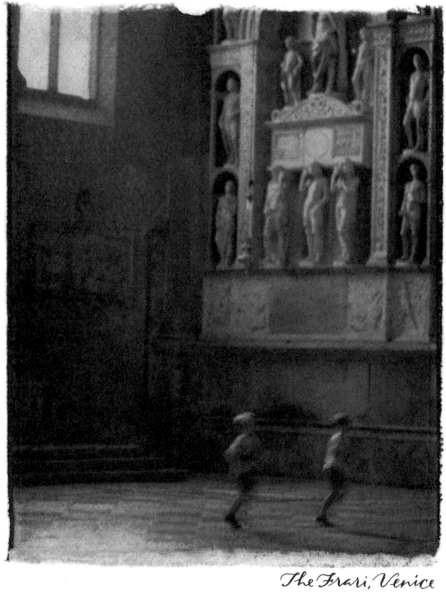

The Frari, Venice

Little soul, wandering, gentle
guest and companion of the body,
into what places will you now go;
pale, stiff, and naked, no longer
sporting as you did. ~ Hadrian

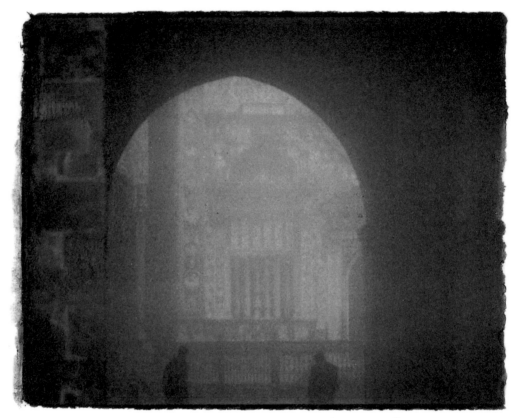

November, Bergamo

. . . that which half emerges from the dim background

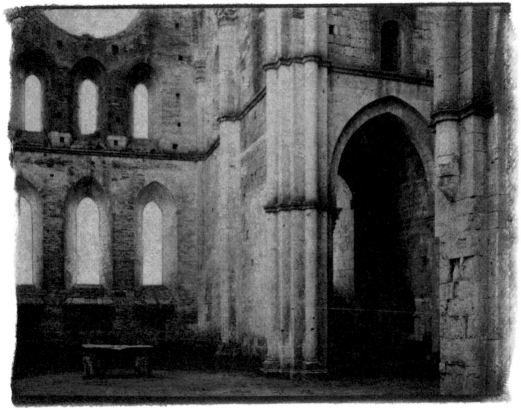

Monastery, San Galgano

of time is strangely stirring. ~ D. H. Lawrence

Fresco, Florence

The Florentine women, less beautiful
than those of Milan, Venice, or Rome,
are more interesting and appeal
more to the mind. Their eyes are
melancholy, their brow is at times
dreamy, and some of them have a
look of vague suffering…
Théophile Gautier

...after the brief narrow experience of her girlhood she was beholding Rome, the city of visible history, where the past of a whole hemisphere seems moving in funeral procession with strange ancestral images and trophies gathered from afar. ~George Eliot

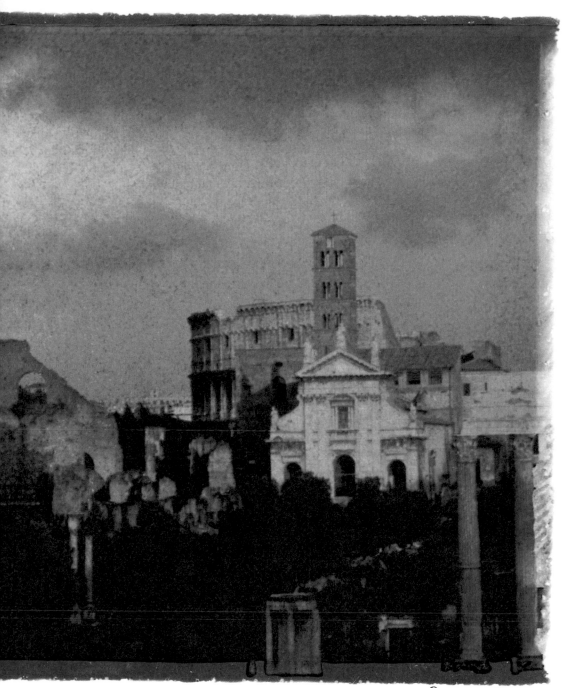

Sunset, Rome

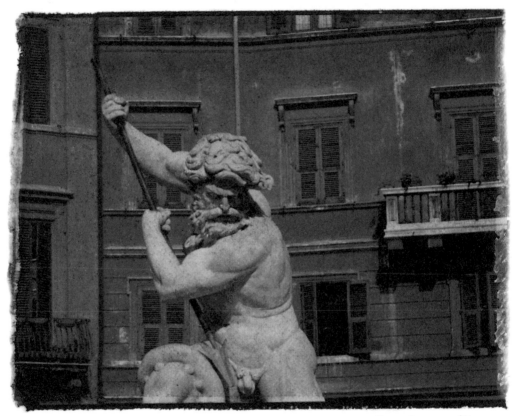

neptune, Rome

We have made you of marble
for the time being. ~ Virgil

Never, in its bloodiest prime, can
the sight of the gigantic Coliseum,
full and running over with the
lustiest life, have moved one heart,
as it must move all who look upon
it now, a ruin. ~ Charles Dickens

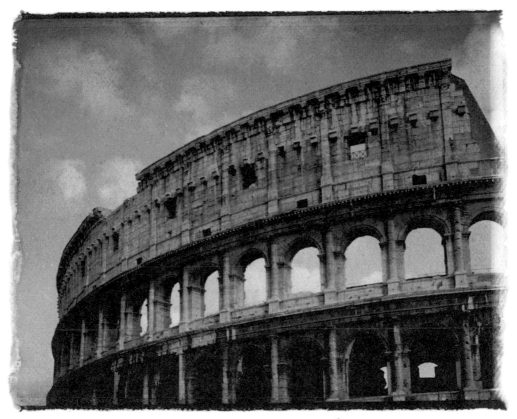

Coliseum detail, Rome

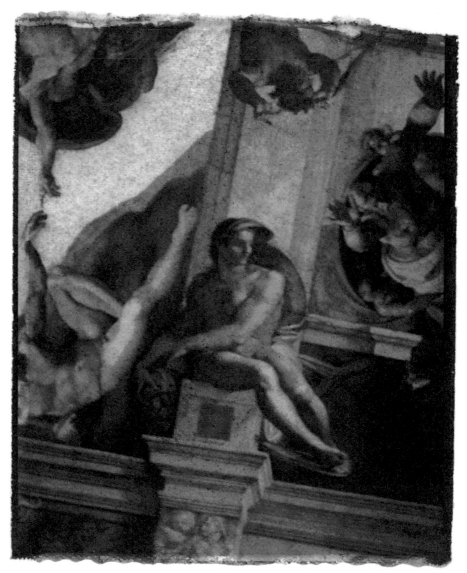

Sistine ceiling, The Vatican

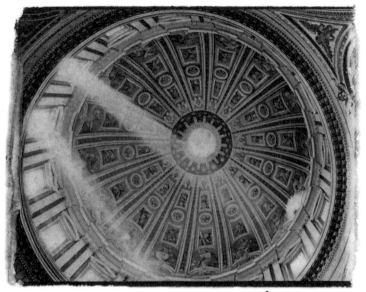

St. Peter's Dome, The Vatican

The soul infinitely expands there,
if one will, but all on its quite human
level. It marvels at the reach of our
dream and the immensity of our
resources. ~ Henry James

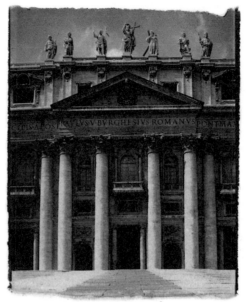

St. Peters, The Vatican

What gorgeous fellows they were,
and, as soldiers, how absurd!
The weapons they bore were as
obsolete as the Inquisition. It was
amusing to pass one of these play-
soldiers on guard at the door of the
Vatican — tall, straight, beautiful,
superb. — William Dean Howells

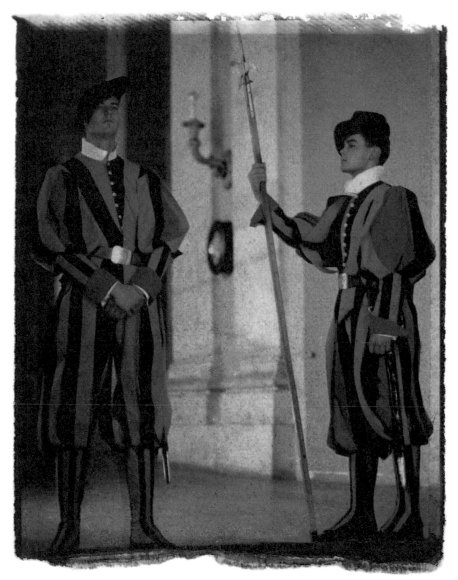

Swiss Guards, The Vatican

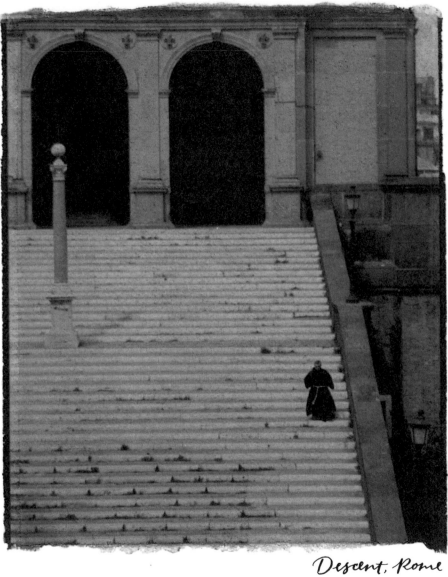

Descent, Rome

I am growing tired of Rome,
The old dead city, with the old dead people;
Priests everywhere, like shadows on a wall,
And morning, noon, and night the ceaseless sound
Of convent bells. I must be gone from here.
~Henry Wadsworth Longfellow

I can honestly say that if I was
told at this moment that I was dying,
not my first, not my second, but
certainly my third thought would be
that I should never see Italy again.
~ Dame Millicent Garrett Fawcett

Good Friday, Rome

BIBLIOGRAPHY

Barzini, Luigi. *The Italians*. New York: Atheneum, 1977.

Berenson, Bernard. *The Passionate Sightseer: From the Diaries, 1947–1956*. New York: Simon & Schuster, 1960.

Dante Alighieri. *La Divina Commedia: Paradiso*. Riccardo Ricciardi Editore, 1957.

Dickens, Charles. *The Works of Charles Dickens: American Notes & Pictures from Italy*. London: Chapman and Hall, 1929.

Di Lampedusa, Giuseppe. *The Leopard*. New York: Pantheon Books, 1987.

Eco, Umberto. *The Name of the Rose*. San Diego: Harcourt Brace Jovanovich, 1983.

Eliot, George. *Middlemarch*. New York: Random House, 1984.

Fawcett, Dame Millicent Garrett. *The Orient Line Guide*. London, 1885.

Forster, E.M. *Where Angels Fear to Tread*. New York: Vintage Books, 1958.

Gautier, Théophile. *The Complete Works of Théophile Gautier*. Bigelow, Smith & Co.

Goethe, J.W. *Italian Journey*. New York: Penguin Books USA, 1992.

Hadrian. *Hadrianus Moriens: Translations, Literal and Free, of the Dying Hadrian's Address to his Soul*. Bath, England: 1876.

Harrison, Barbara Grizzuti. *Italian Days*. New York: Ticknor & Fields, 1990.

Hawthorne, Nathaniel. *Passages from the French and Italian Notebooks*. Boston: Houghton, Mifflin and Company, 1883.

Hazan, Marcella. *Essentials of Classic Italian Cooking*. New York: Alfred A. Knopf, 1992.

Howells, William Dean. *Italian Journeys*. Marlboro, VT: The Marlboro Press, 1988.

James, Henry. *Collected Travel Writings: The Continent*. New York: Library of America, 1993.

Kazantzakis, Nikos. *Saint Francis*. New York: Simon & Schuster, 1962.

Lawrence, D.H. *Etruscan Places*. New York: Viking Press, 1932.

Longfellow, Henry Wadsworth. *Judas Maccabees/Michael Angelo/Translations*. Boston & New York: Houghton, Mifflin & Company, 1901.

McCarthy, Mary. *Venice Observed*. New York: Harcourt, Brace & Co., 1963.

Ovid. *The Metamorphoses of Ovid*. Baltimore: Johns Hopkins University Press, 1994

Shakespeare, William. *Romeo and Juliet*. New York: Random House, 1990.

Shelley, Percy Bysshe. *The Complete Works of Shelley*. Edited by Roger Ingpen and Walter E. Peck. New York: The Gordian Press, 1965.

Simon, Kate. *Italy: The Places in Between*. New York: Harper & Row, 1970.

Stendhal. *Rome, Naples, & Florence*. New York: George Braziller.

Twain, Mark. *The Innocents Abroad*. New York: Penguin Books USA.

Virgil. *The Greater Poems of Virgil, Vol. 2, Containing the Eclogues*. Edited by J.B. Greenough and G.L. Kittredge. New York: Caratzas Bros., 1976.

Wall, Bernard. *A City and a World: A Roman Sketchbook*. New York: W.W. Norton & Co., 1962.

STEVEN ROTHFELD has created the images for several books including *Savoring the Wine Country* (Collins, 1995), *French Dreams* (Workman, 1994) and Patricia Wells' *Trattoria* (Morrow, 1993). His work has appeared in *European Travel & Life, Bon Appetit, Departures* and *Travel & Leisure* magazines and is represented by the Gallery of Contemporary Photography in Santa Monica, California.

Also available from Collins Publishers: *Italian Dreams* boxed notecards